Calming Colouring

flower patterns

BATSFORD

First published in the United Kingdom in 2016 by
Batsford
1 Gower Street
London
WC1E 6HD

An imprint of Pavilion Books Company Ltd

Illustrations copyright © Graham Leslie McCallum, 2016
Volume copyright © Batsford, 2016

ISBN: 978-1-84994-383-3

A CIP catalogue record for this book is available from the British Library.

20 19 18 17 16
10 9 8 7 6 5 4 3 2 1

Reproduction by Mission Productions, Hong Kong
Printed by GPS Group, Slovenia

This book can be ordered direct from the publisher at the website: www.pavilionbooks.com, or try your local bookshop.

Distributed in the United States and Canada by
Sterling Publishing Co., Inc. 1166 Avenue of the Americas, 17th floor, New York, NY 10036, USA

Calming Colouring

flower patterns

80 mindful patterns to colour in

Graham Leslie McCallum

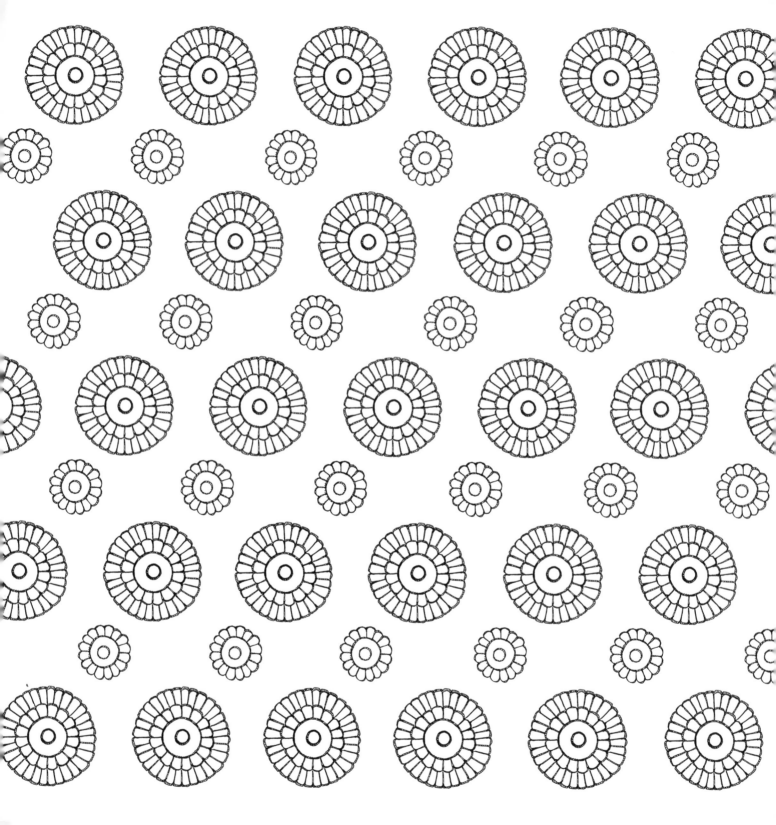

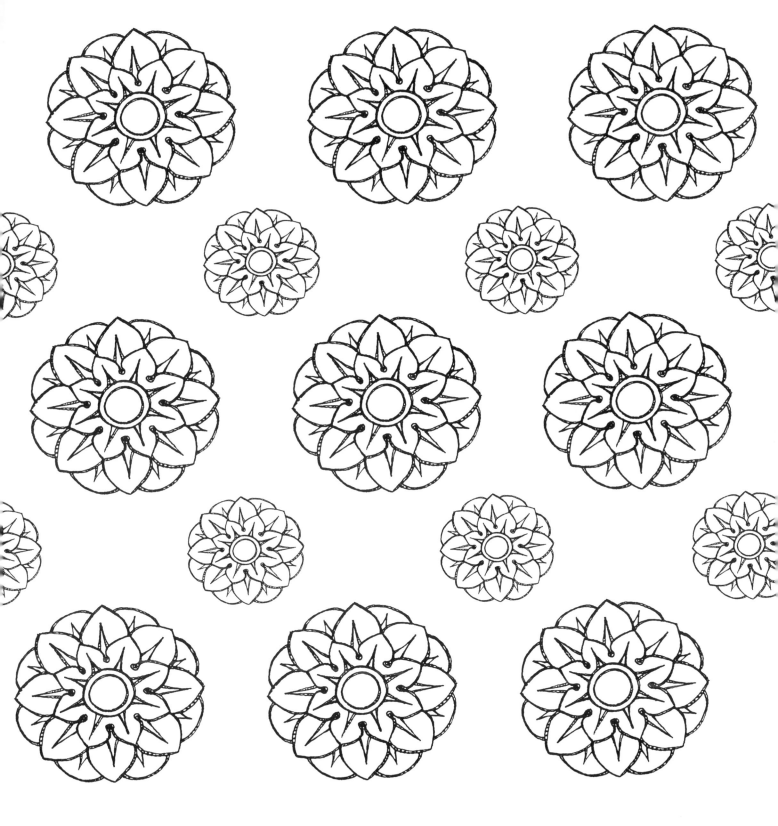

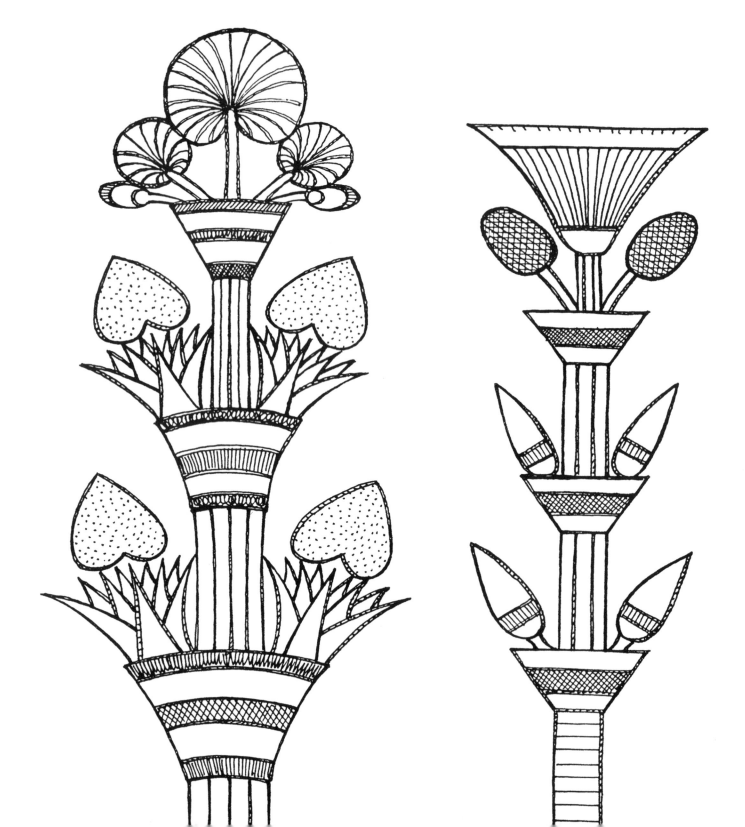

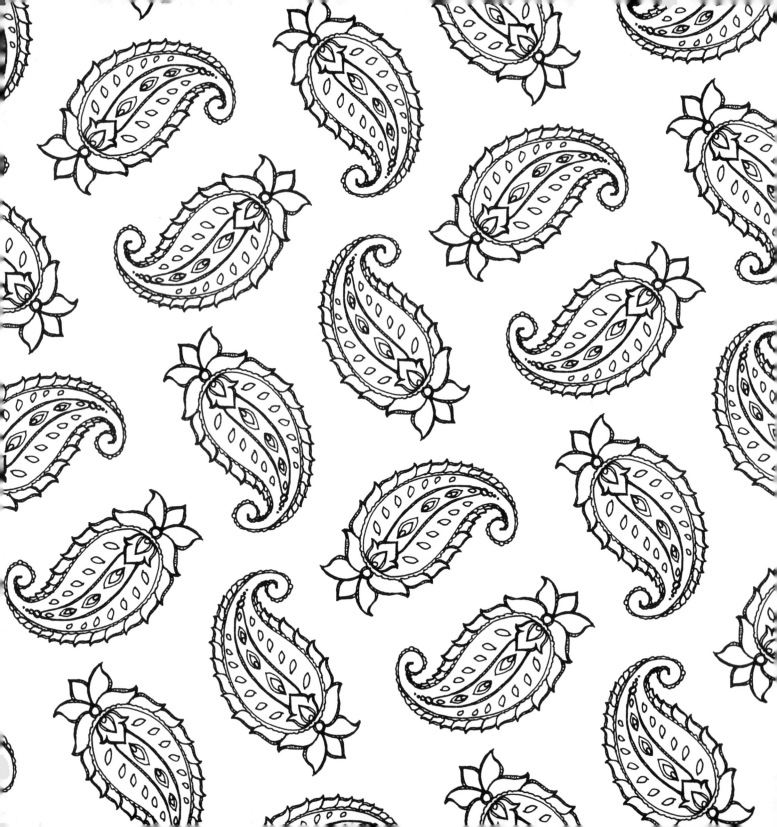

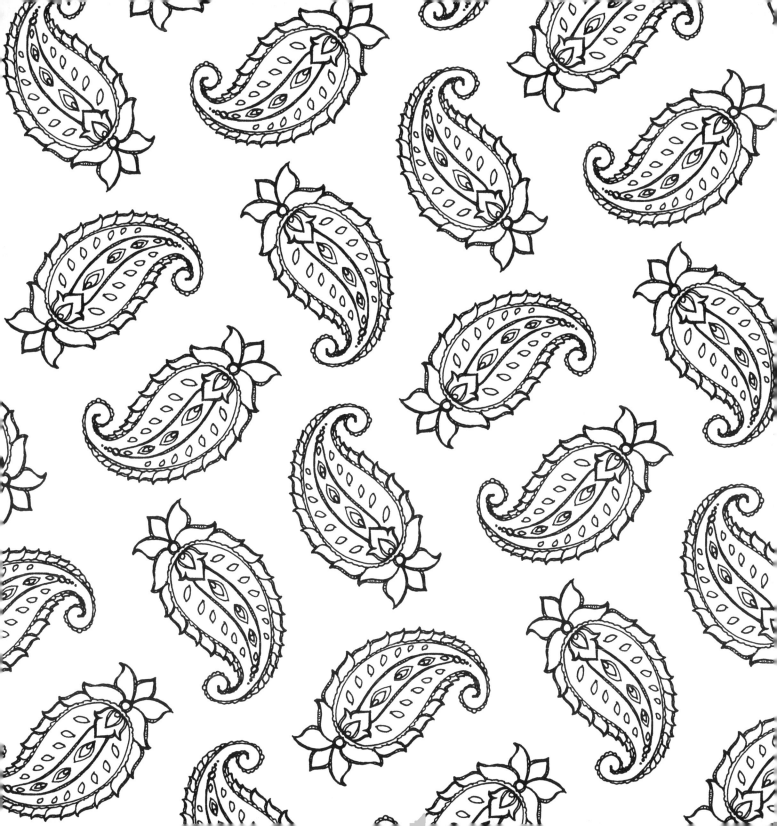

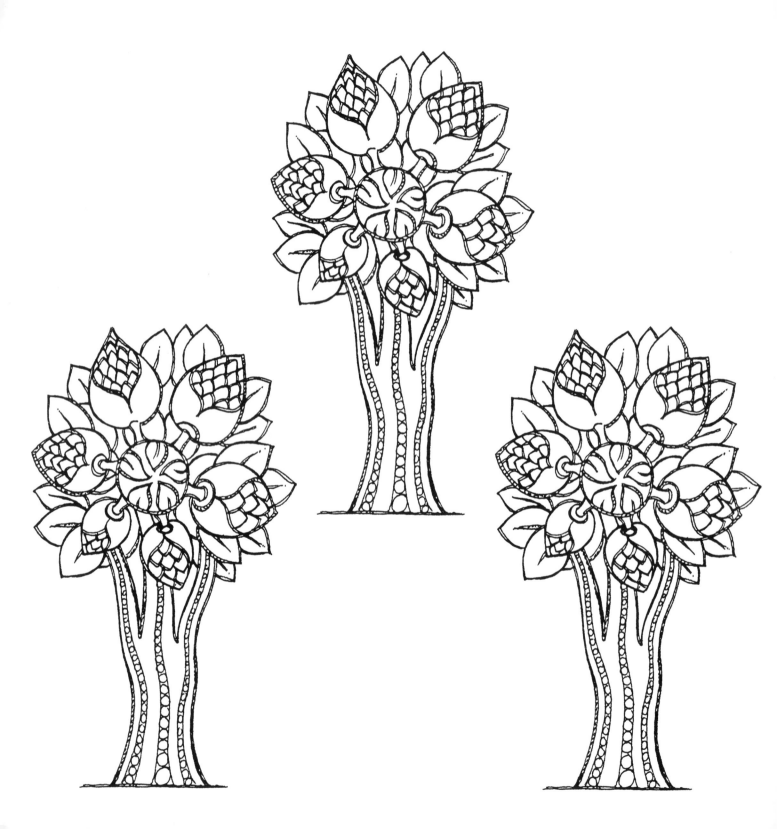

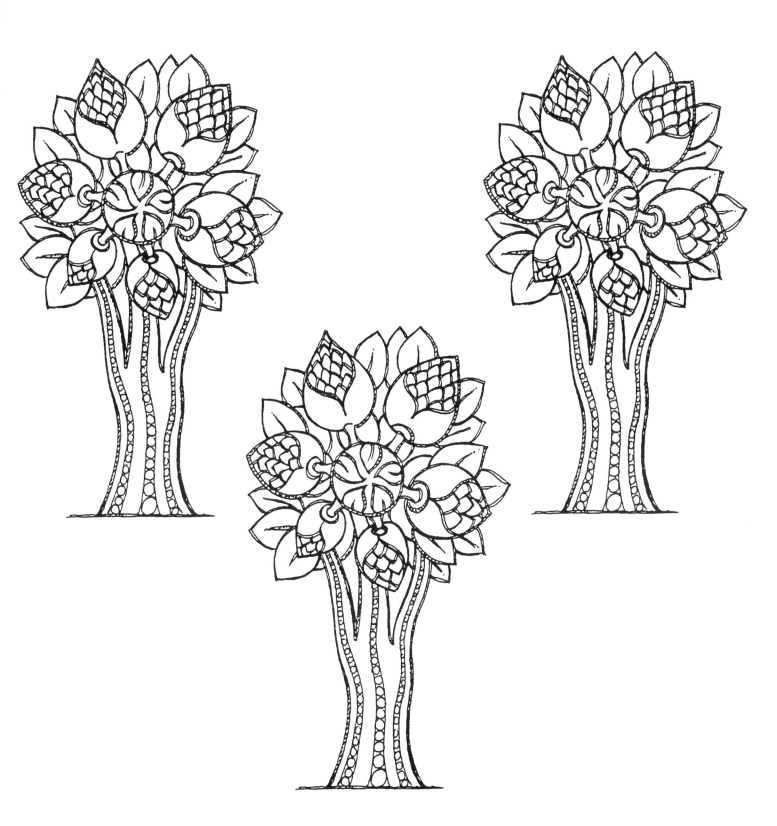

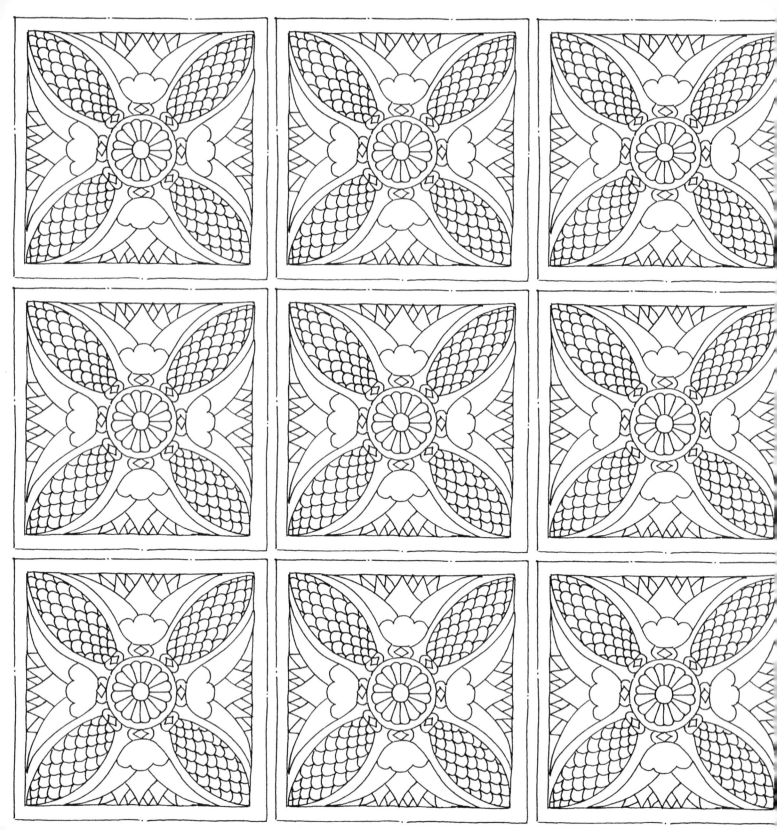

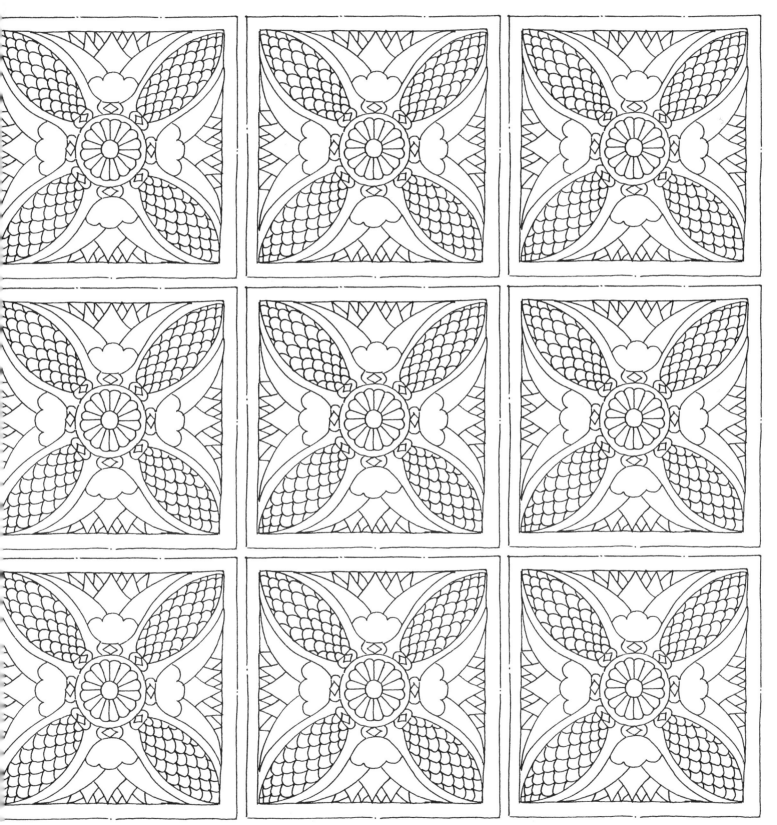

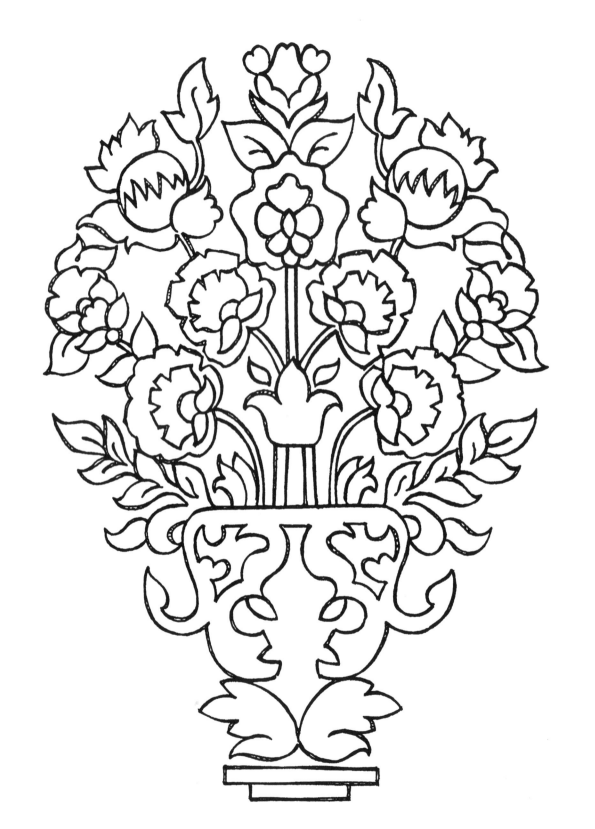

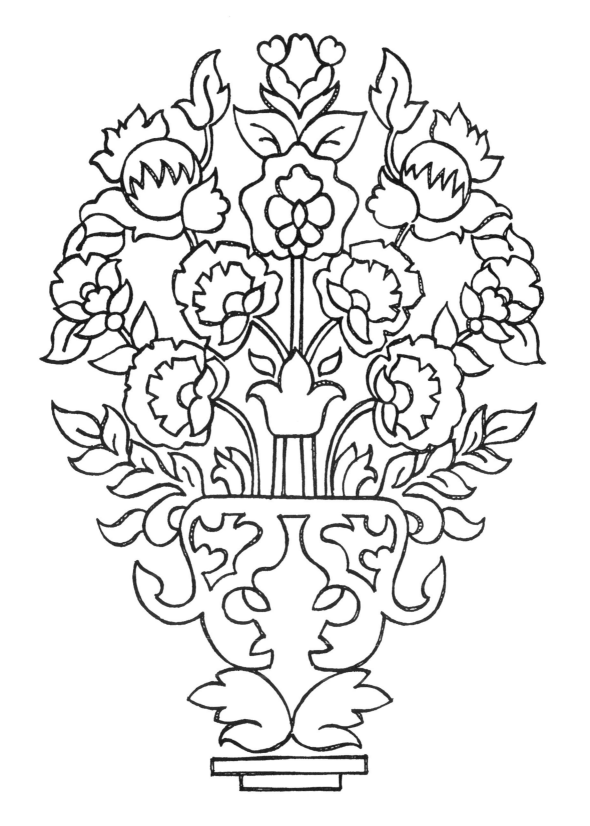

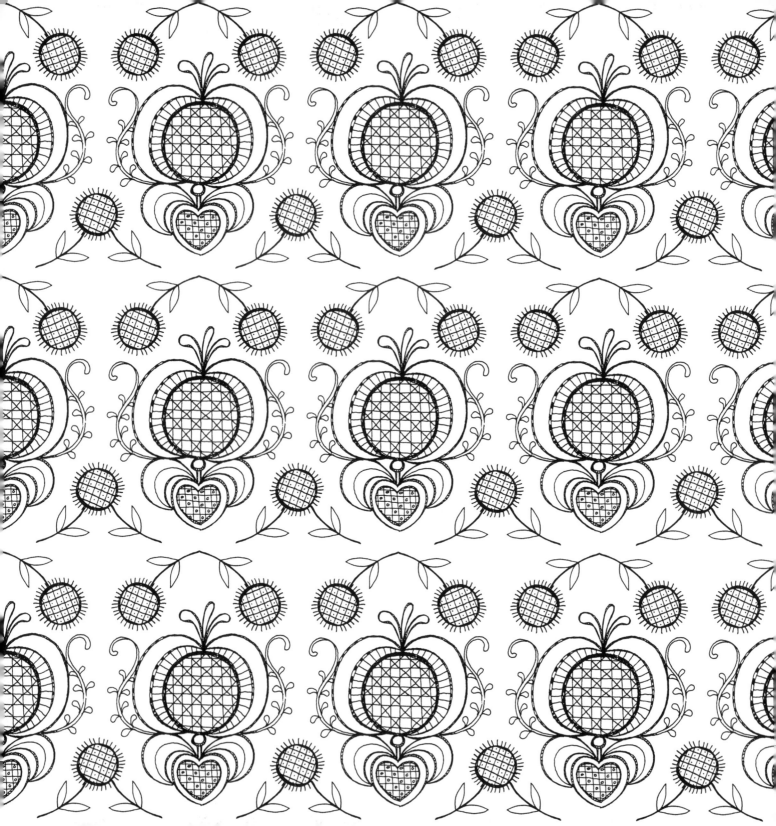

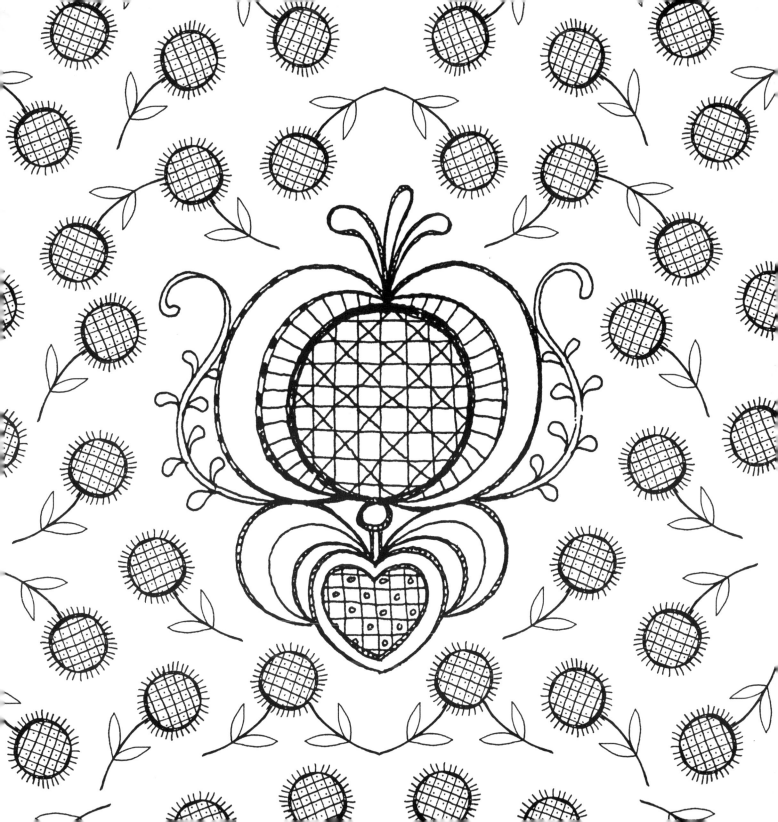

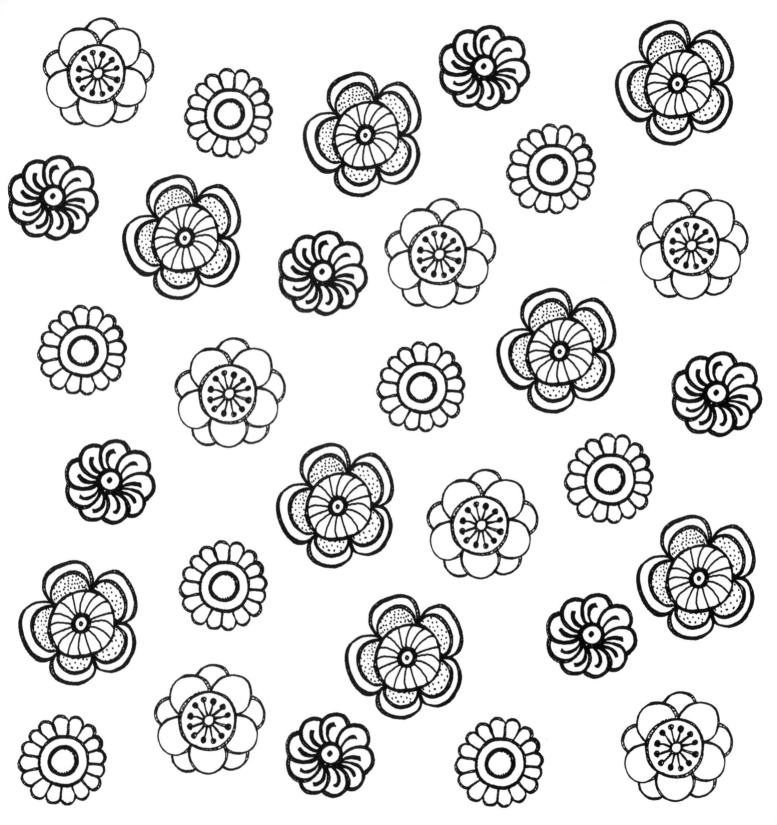

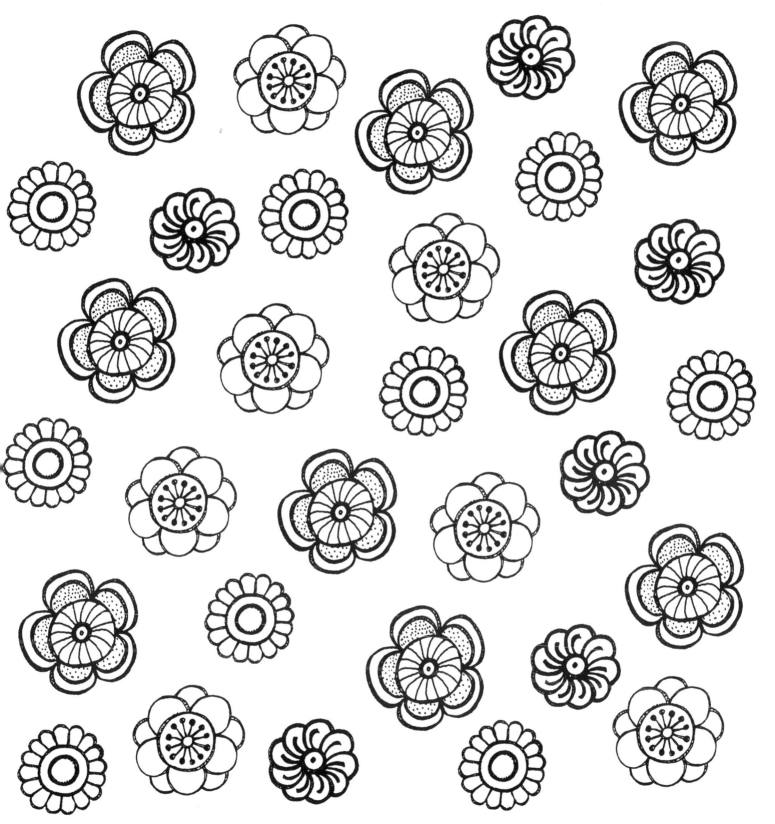

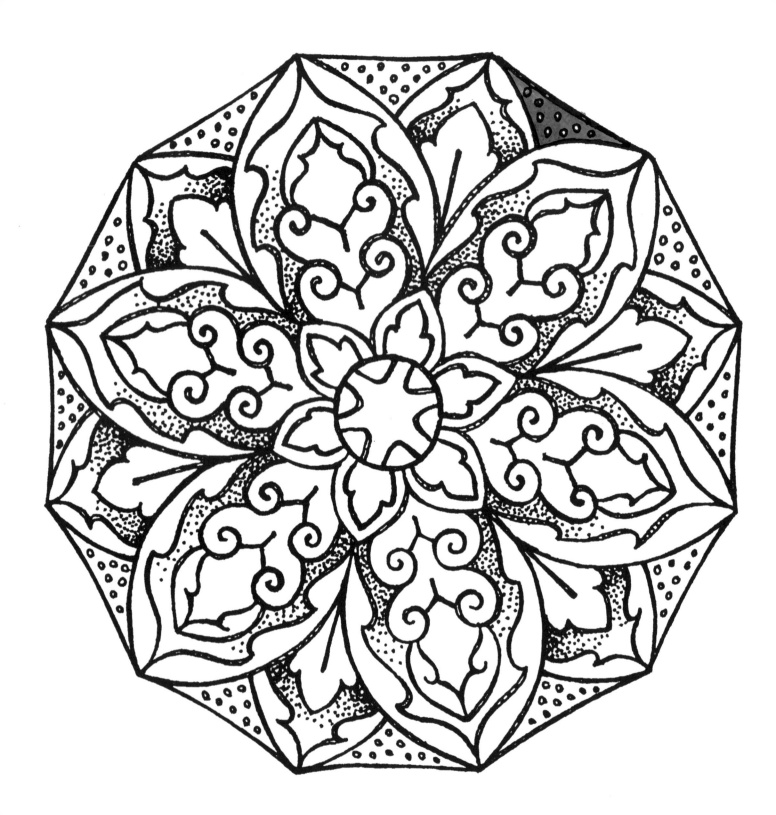

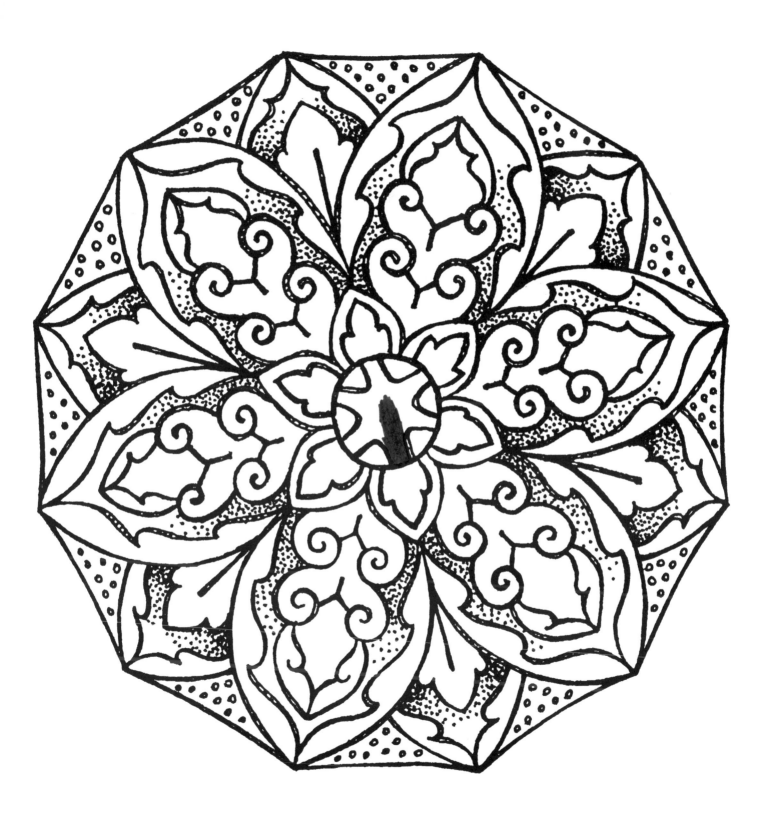

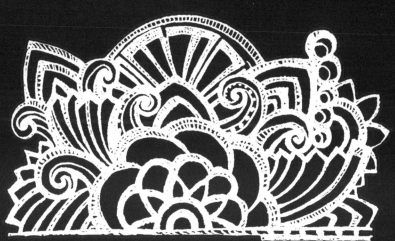

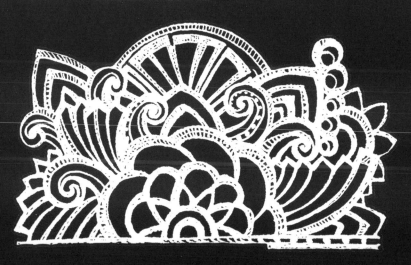

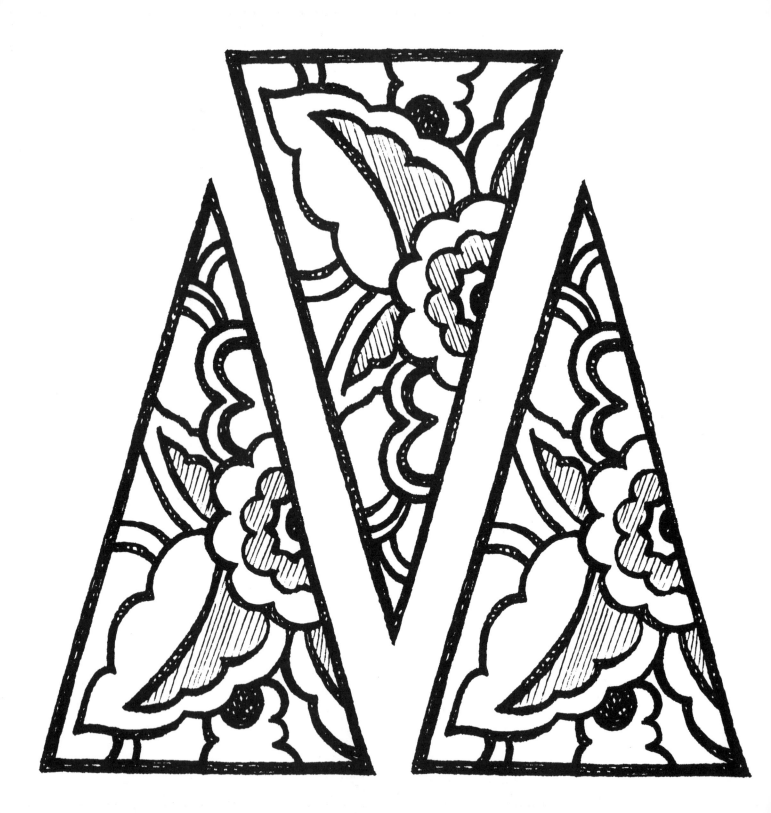

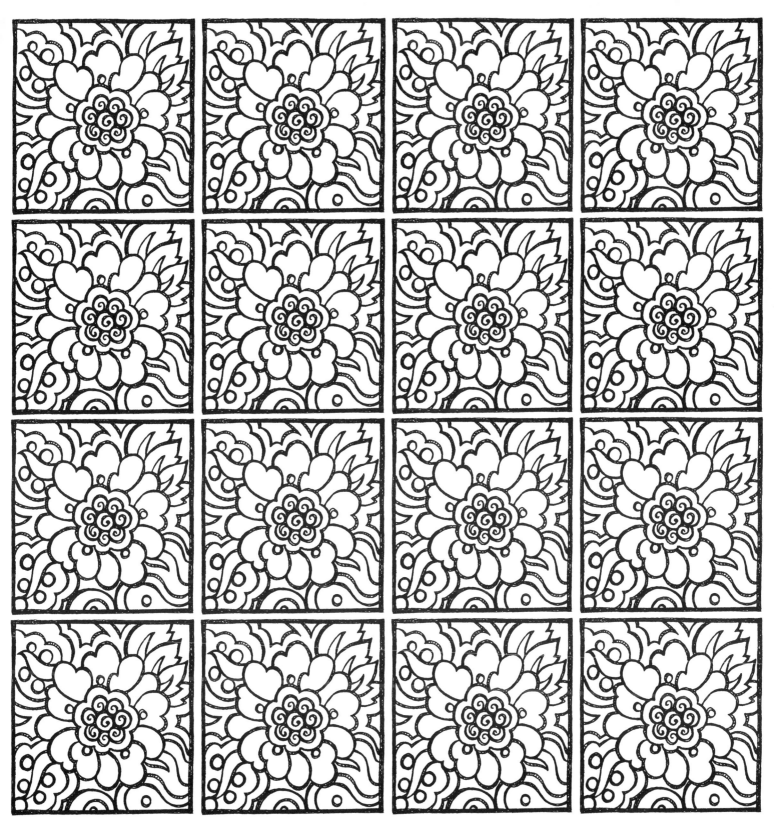

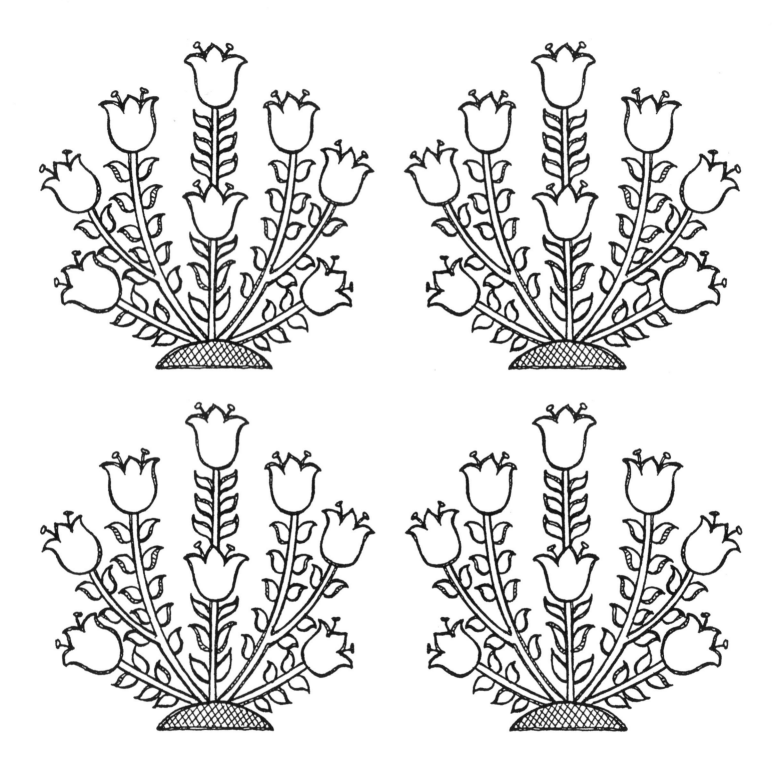

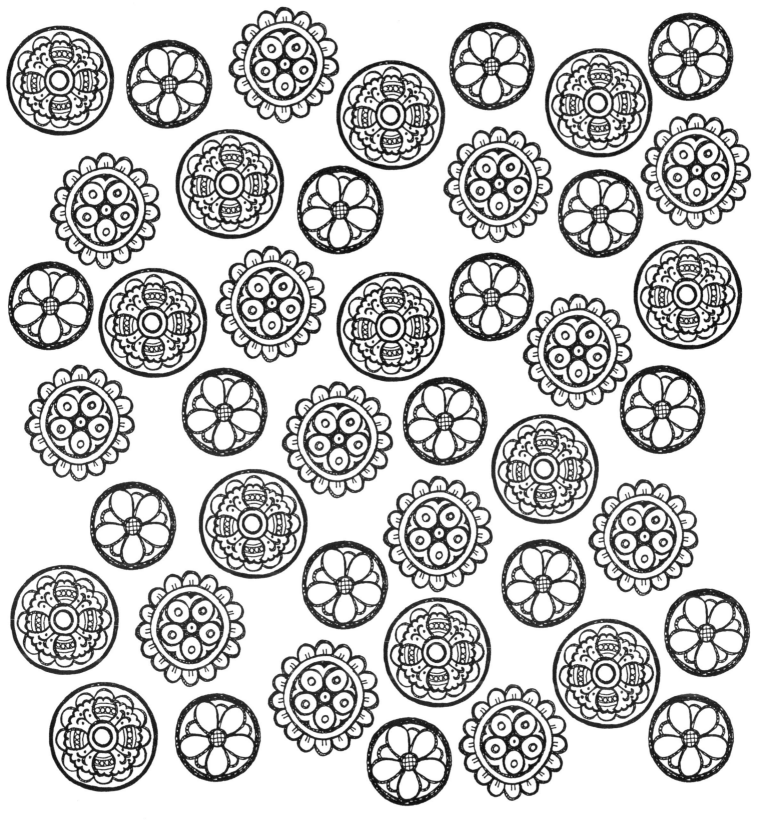

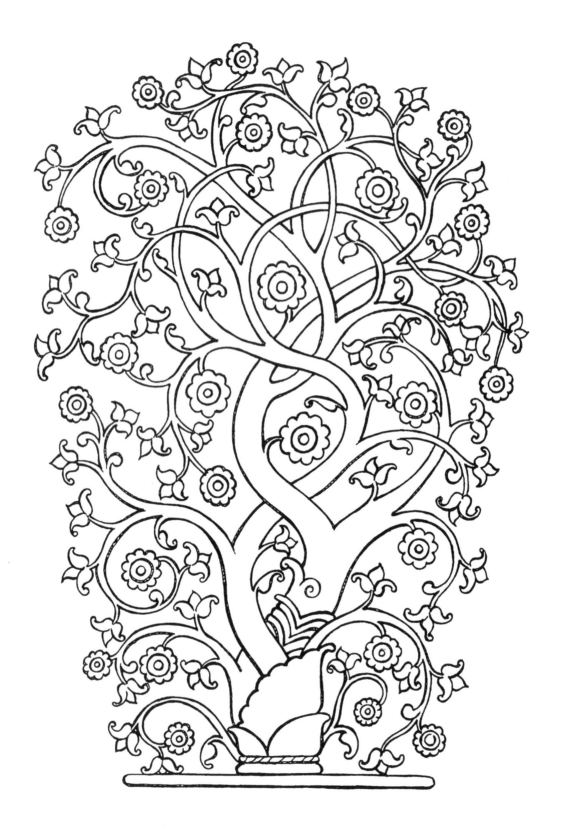

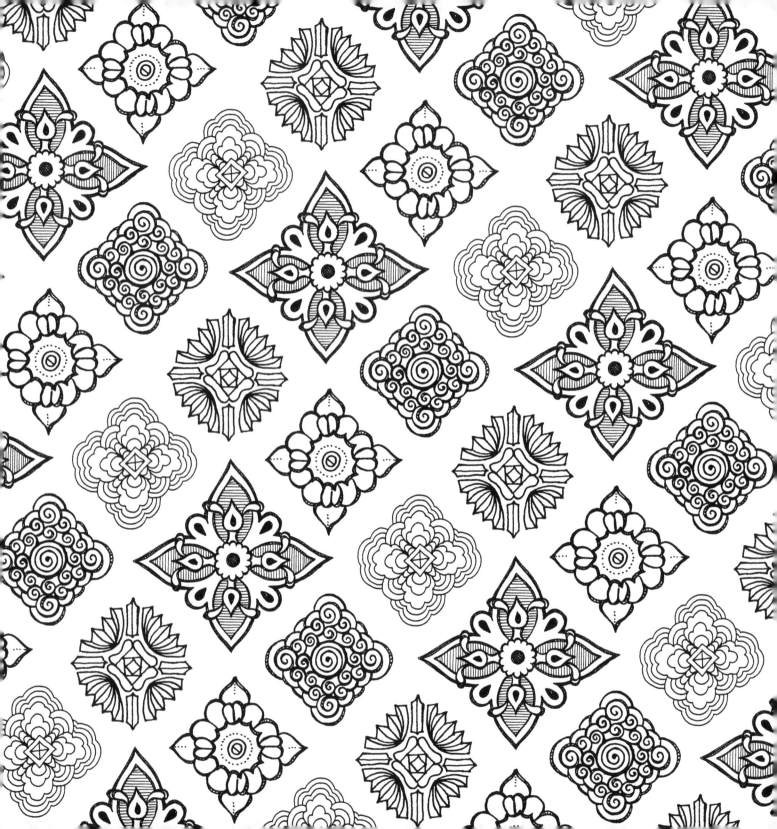

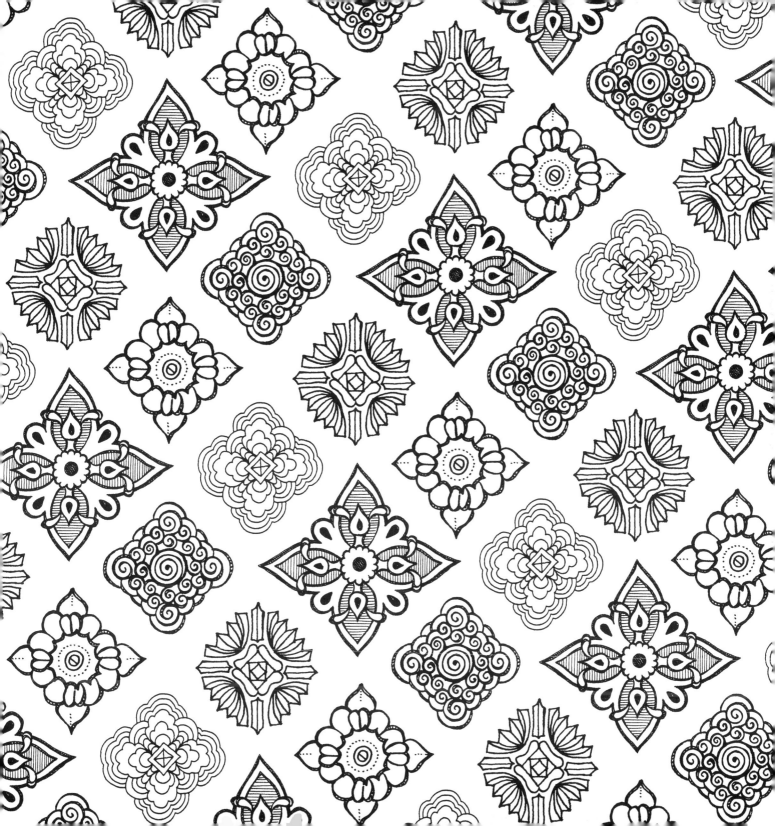

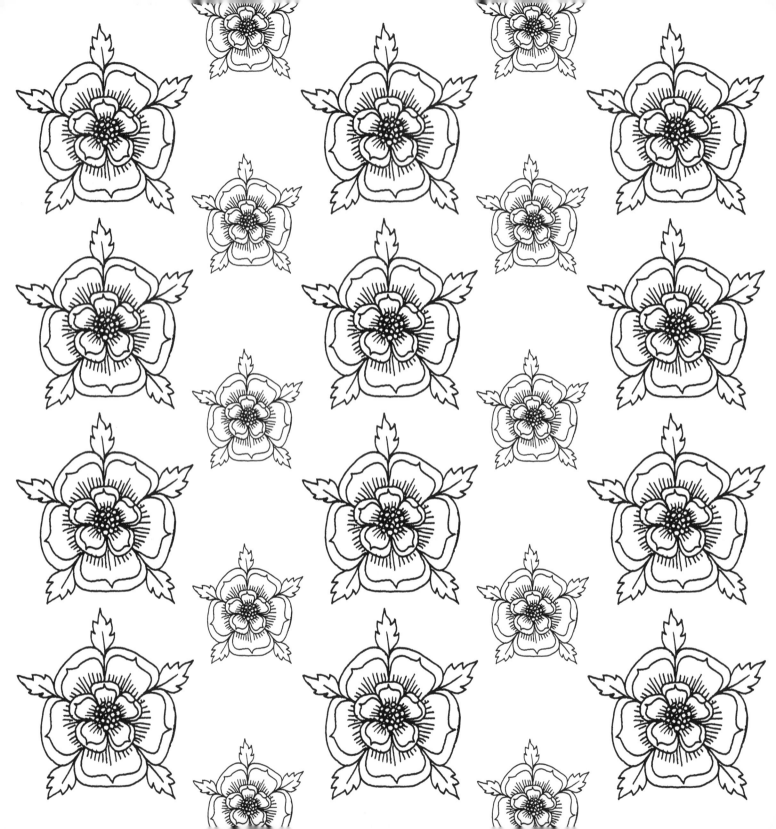

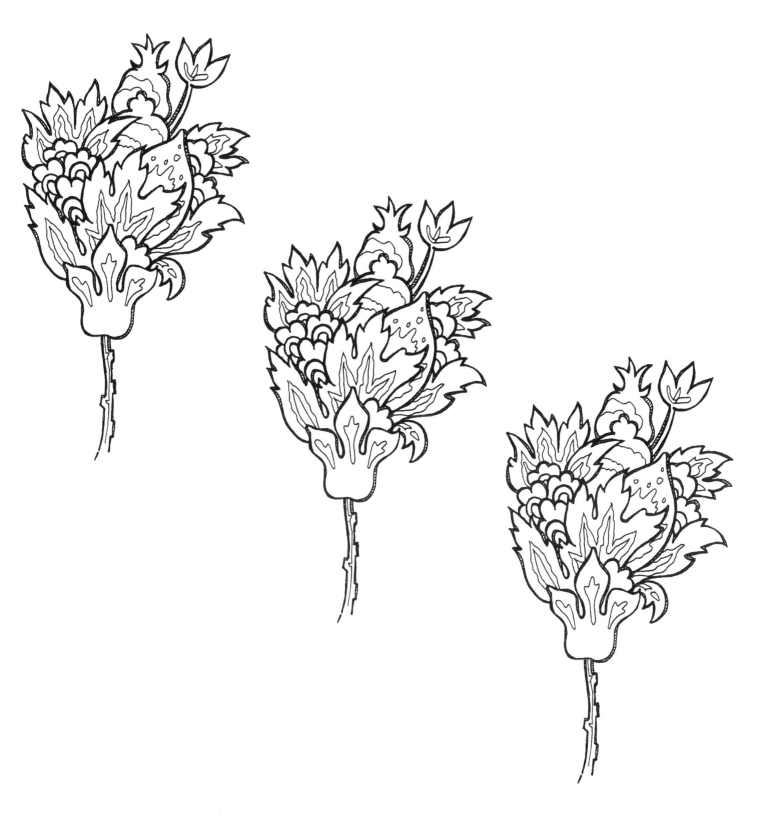

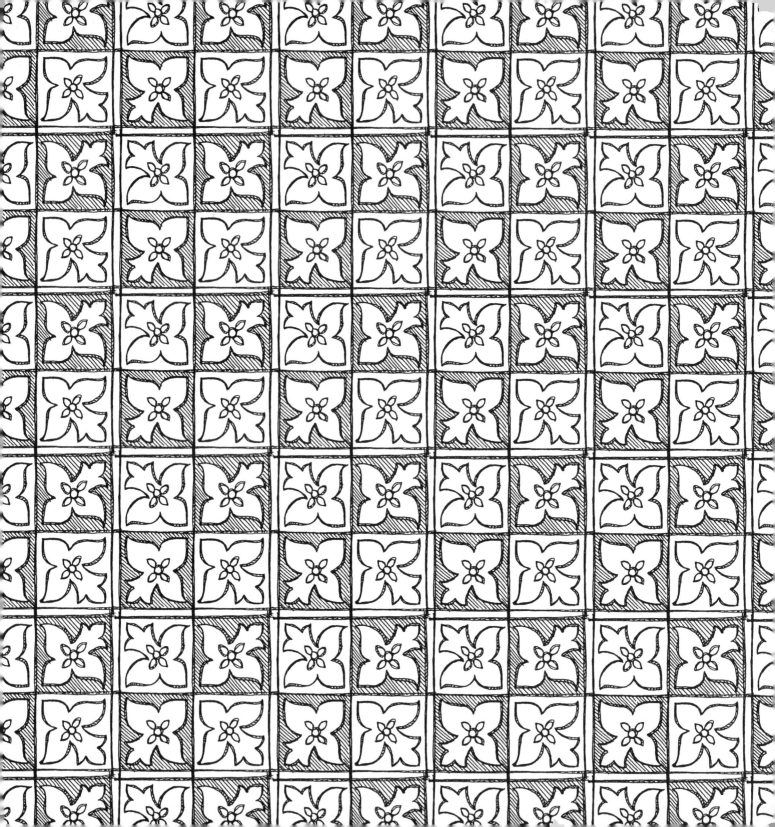

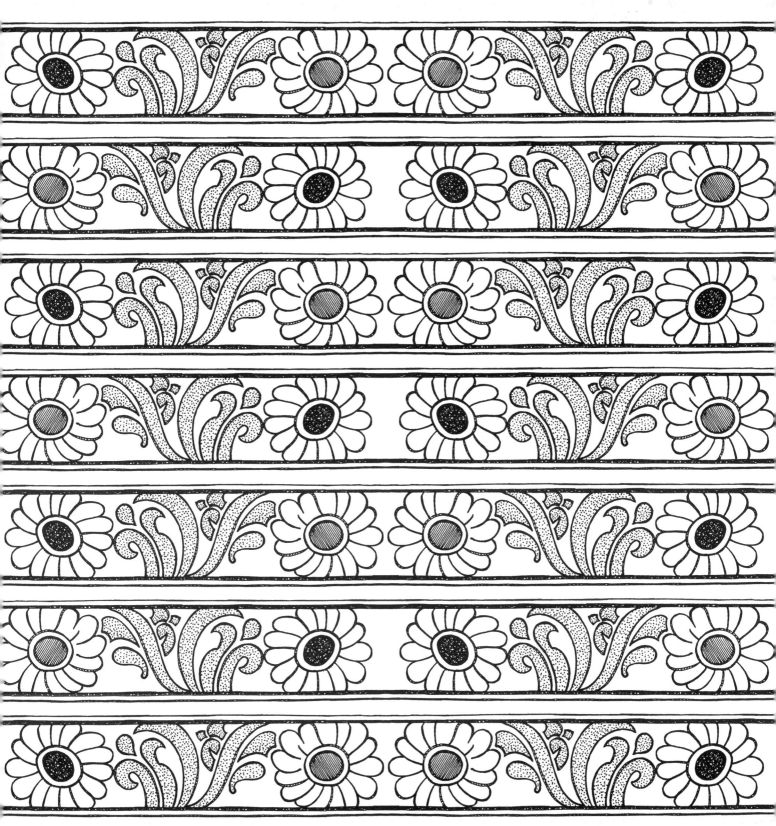

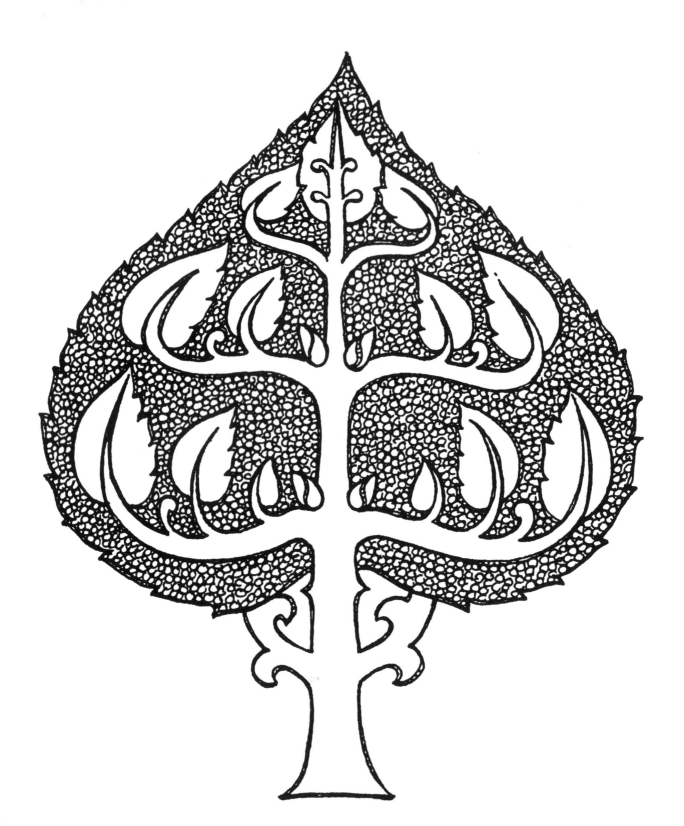

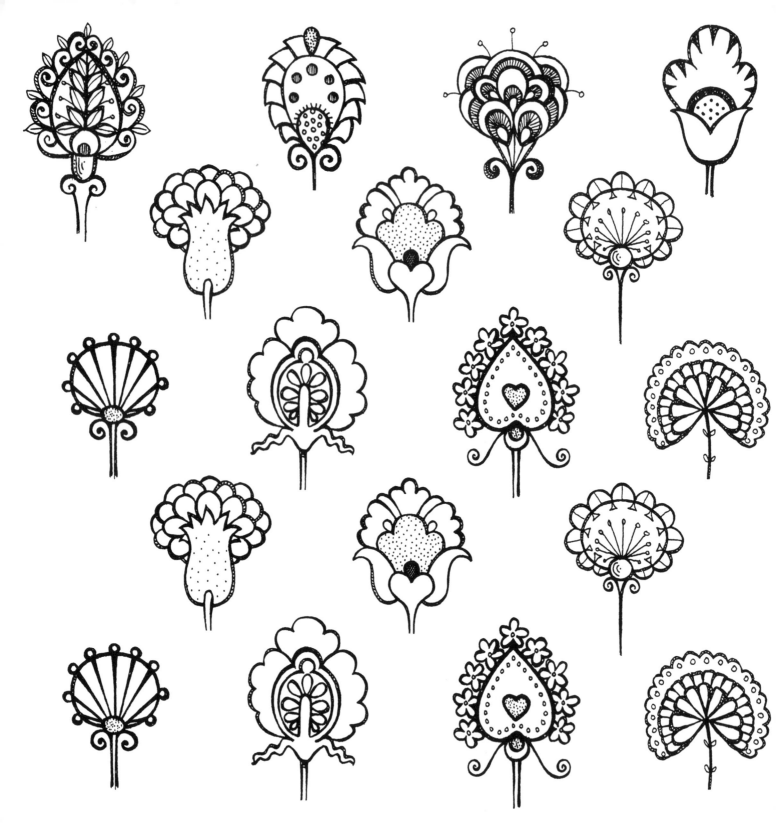

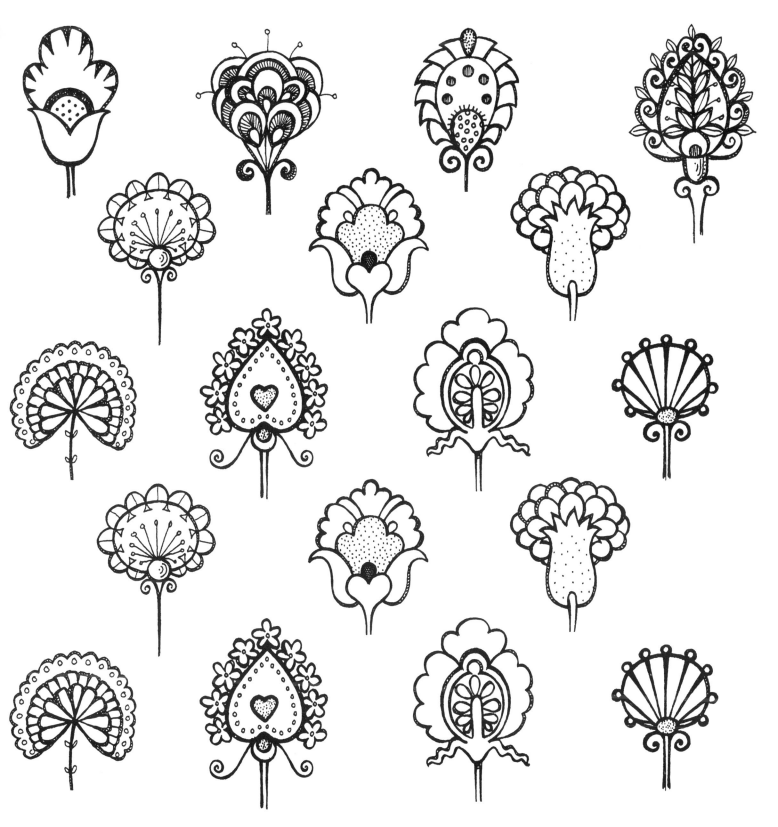

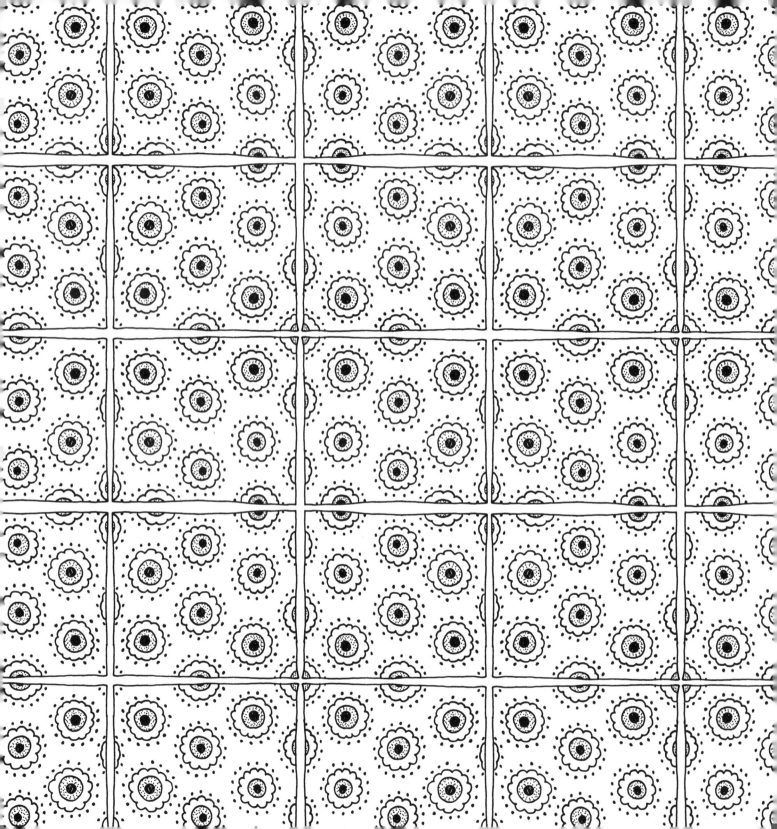

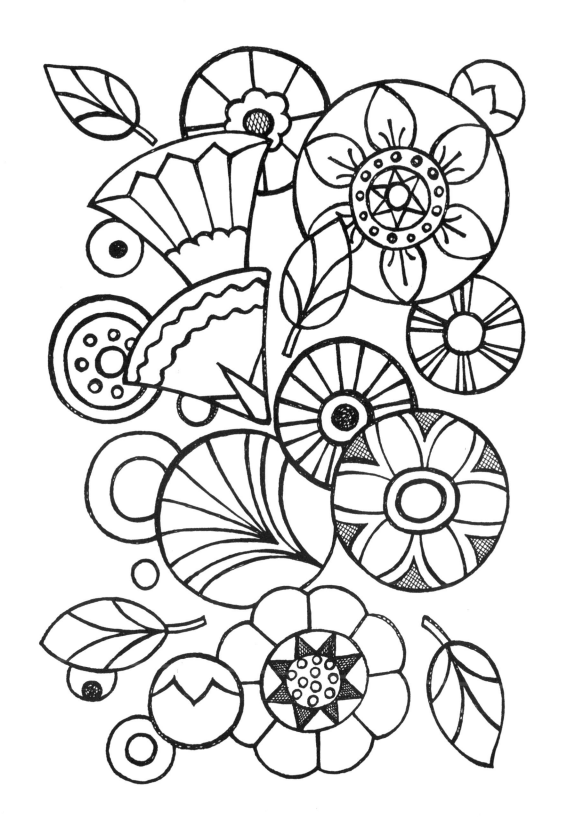

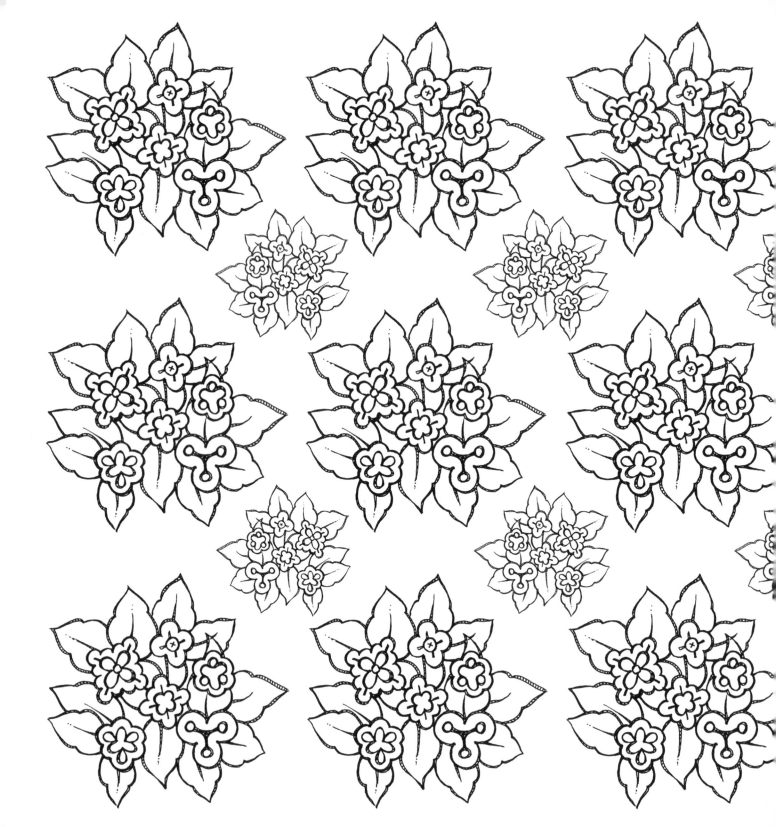

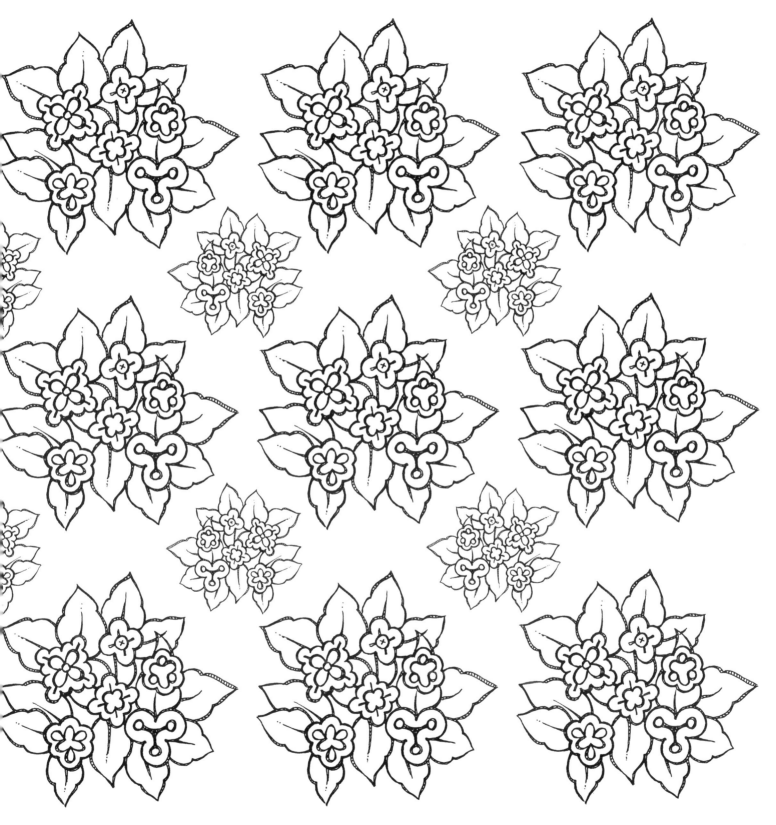

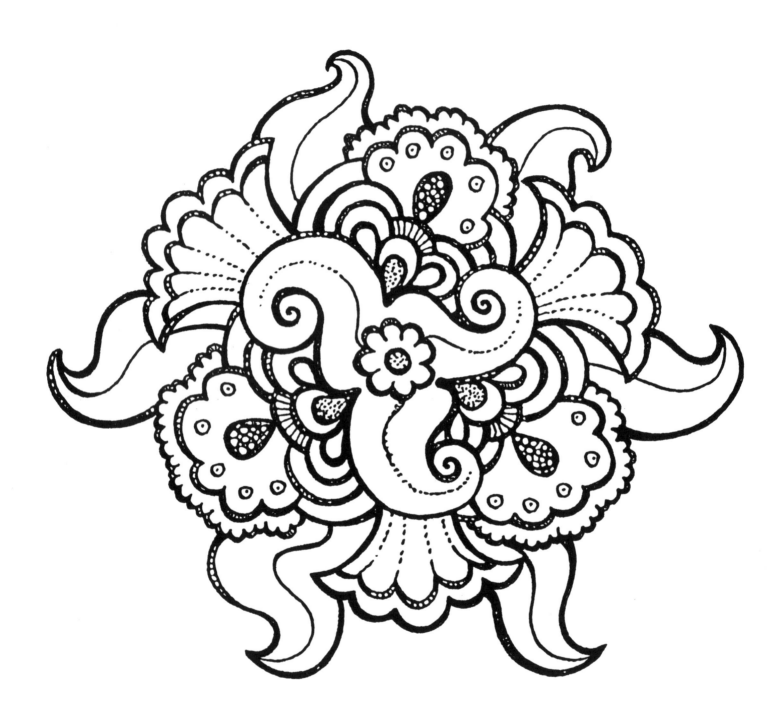

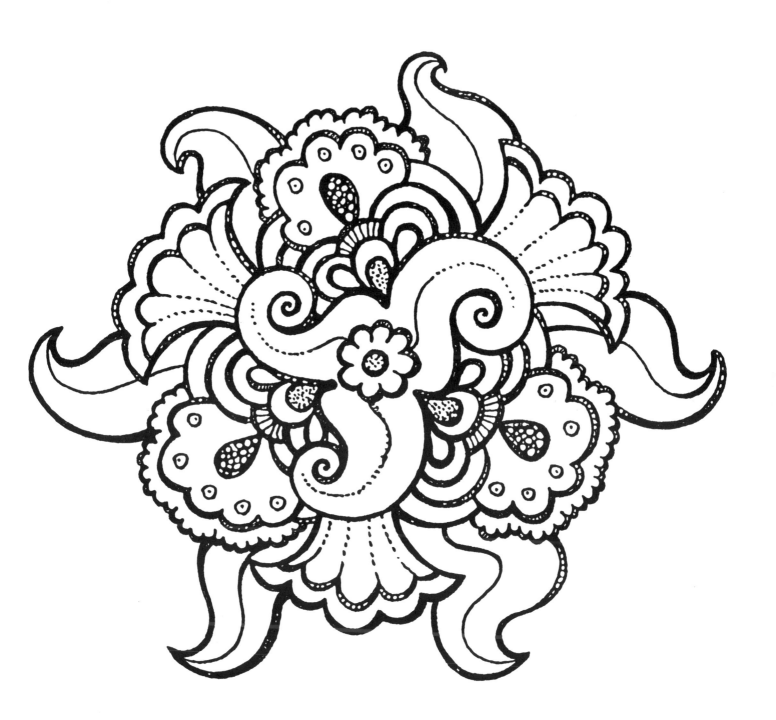

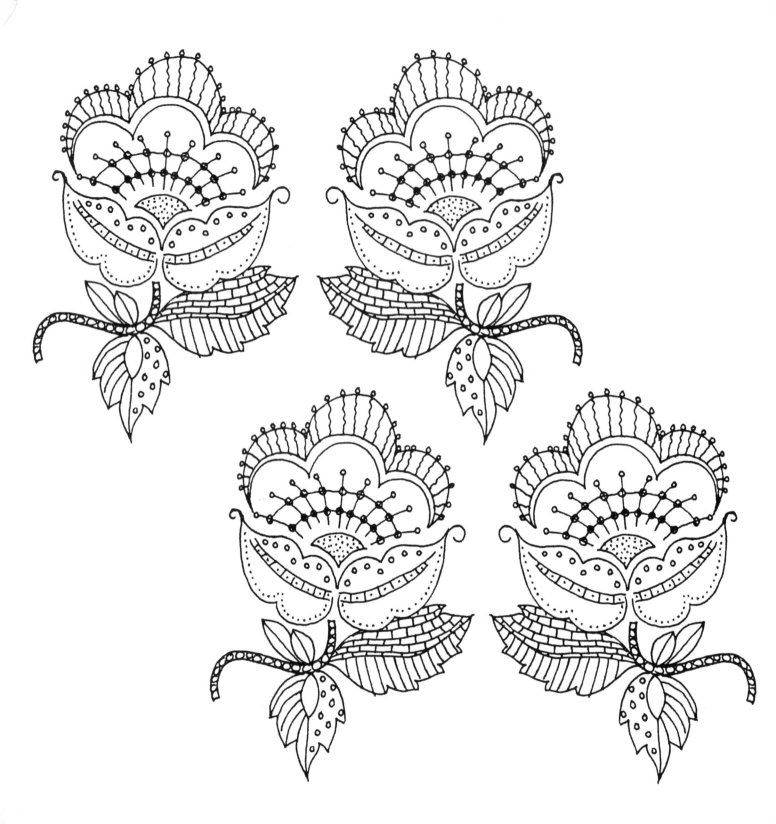

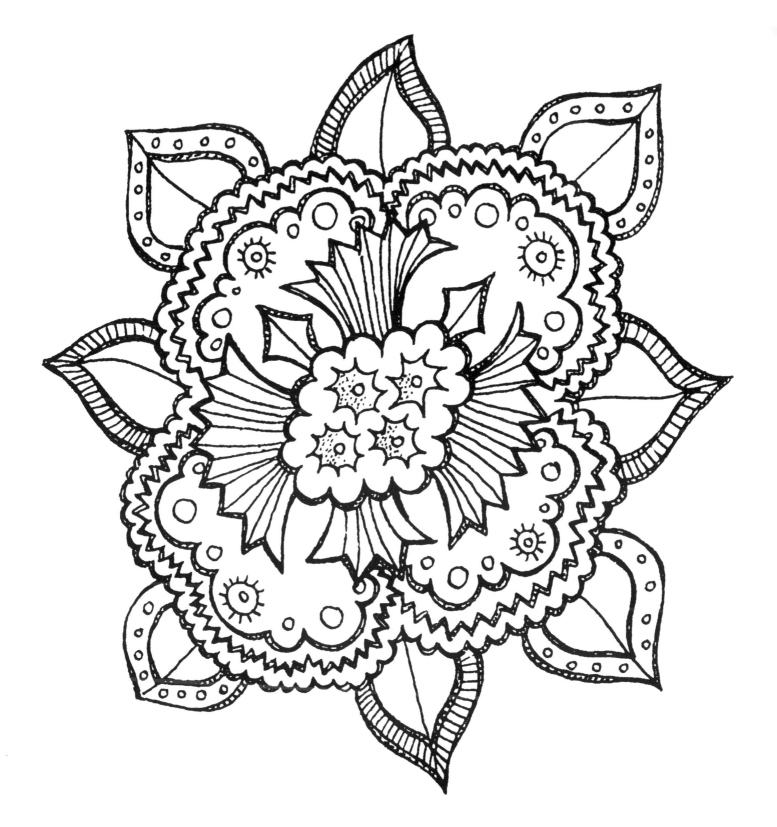

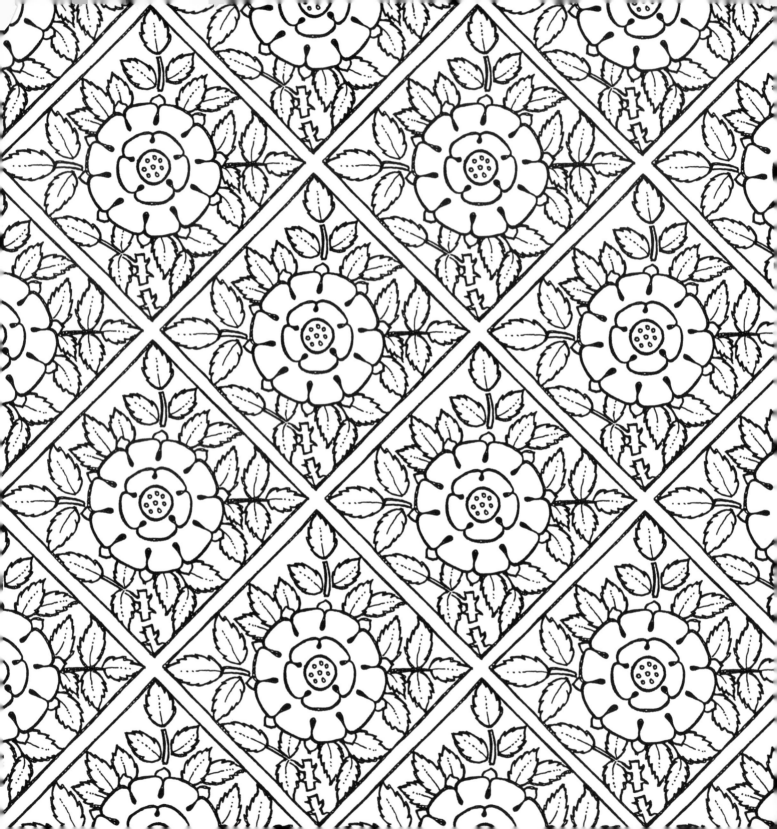

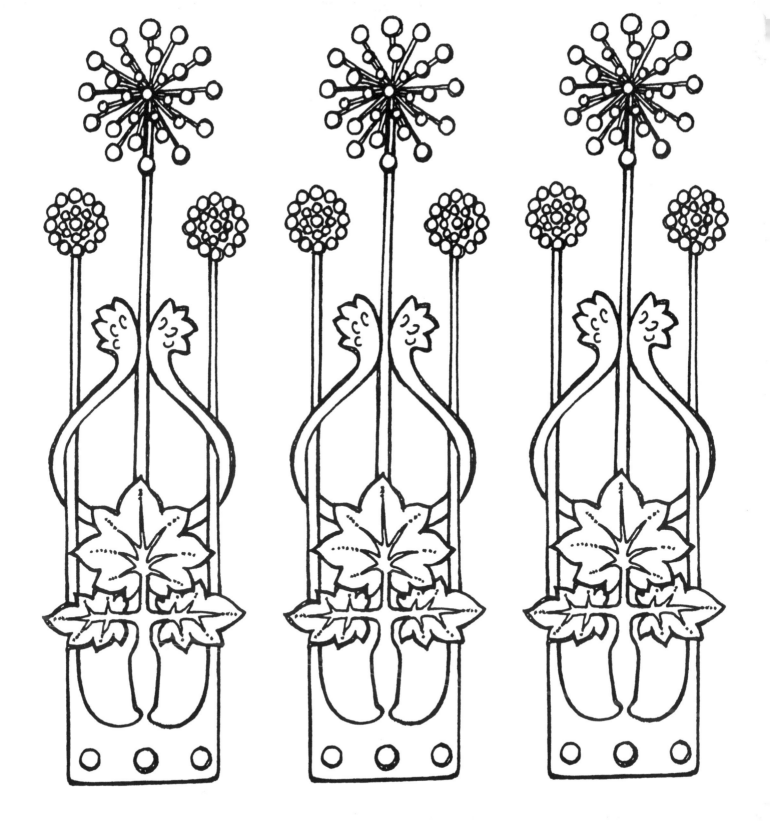

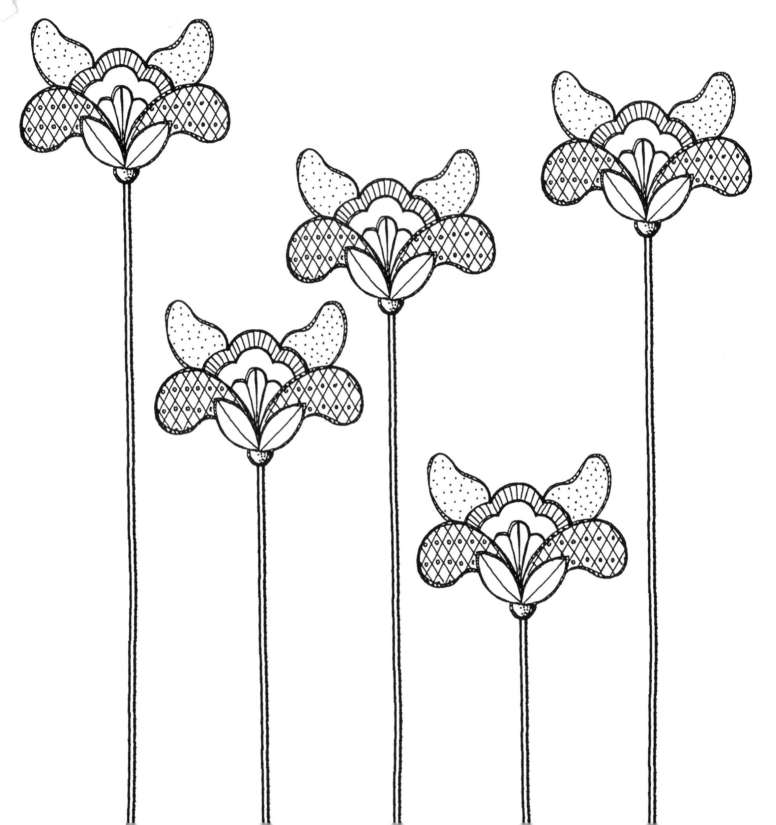

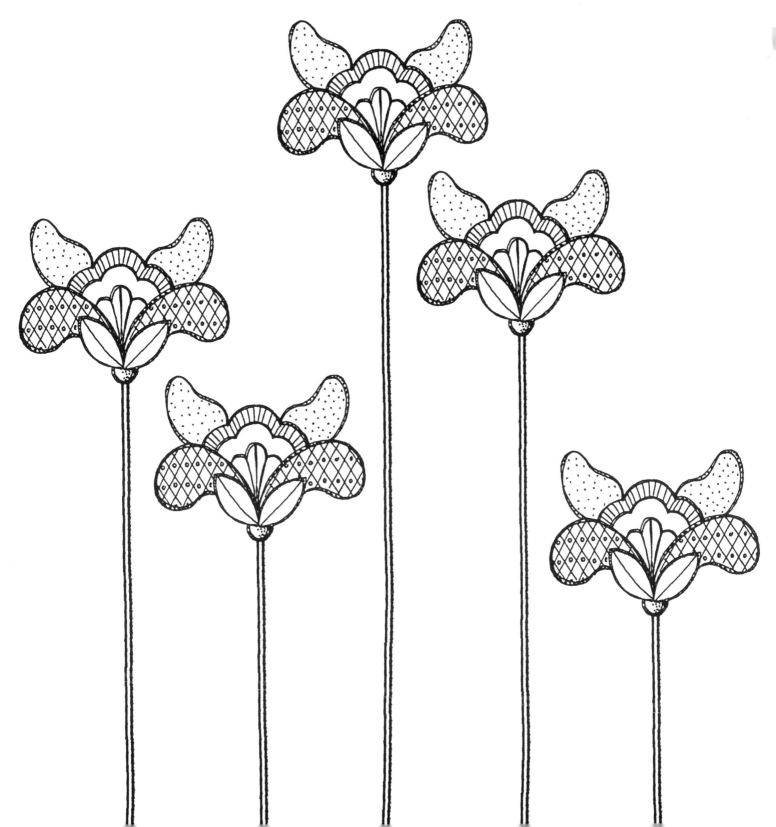

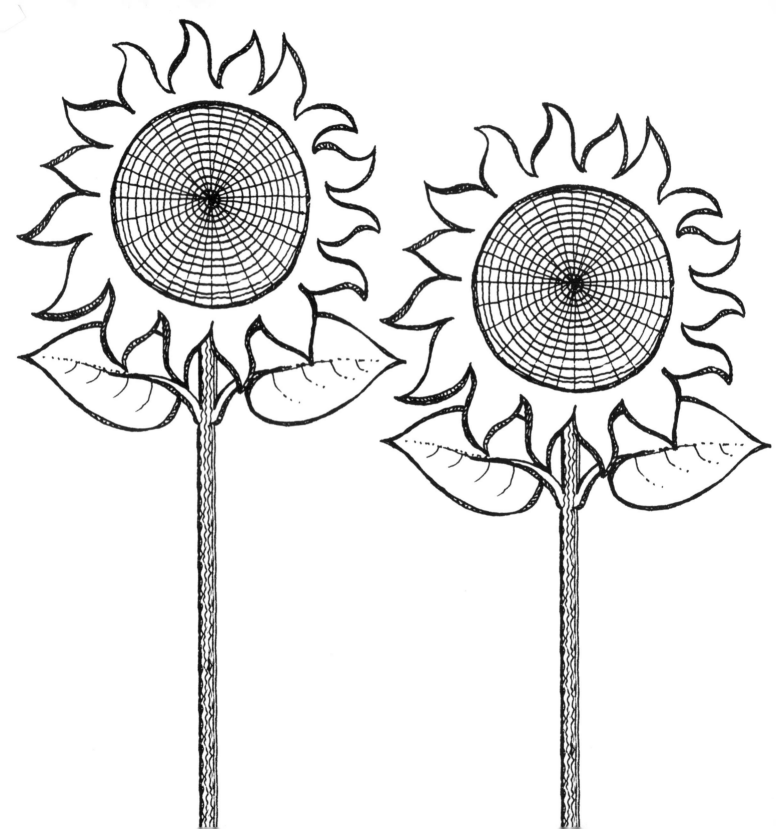

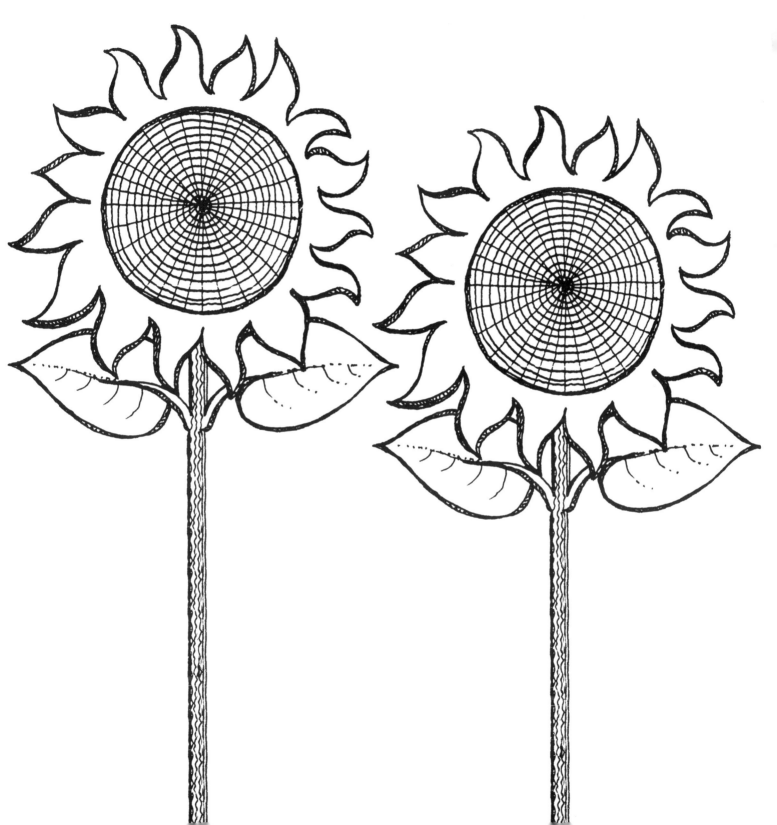

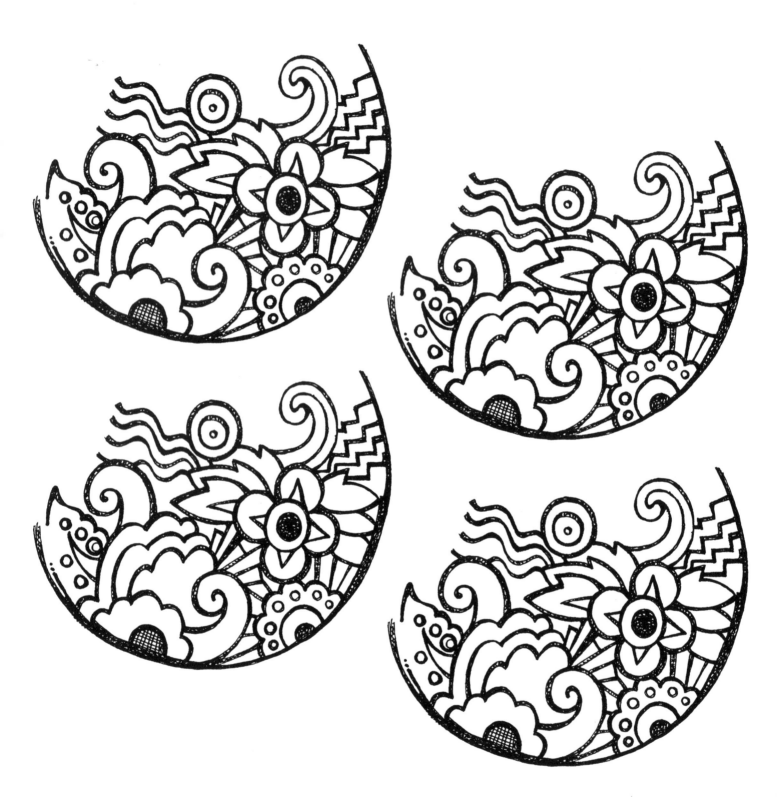

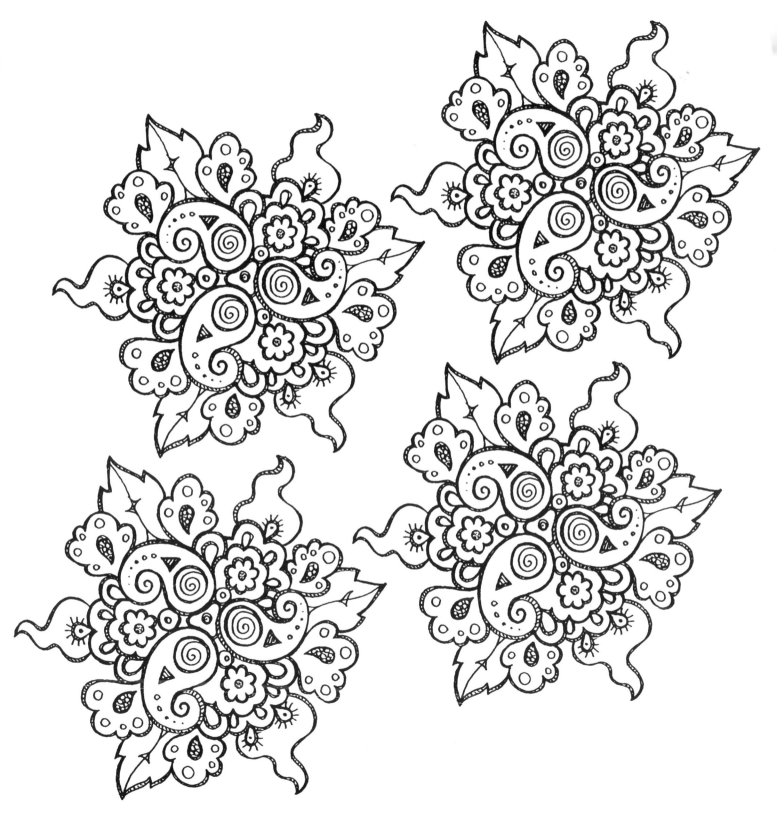

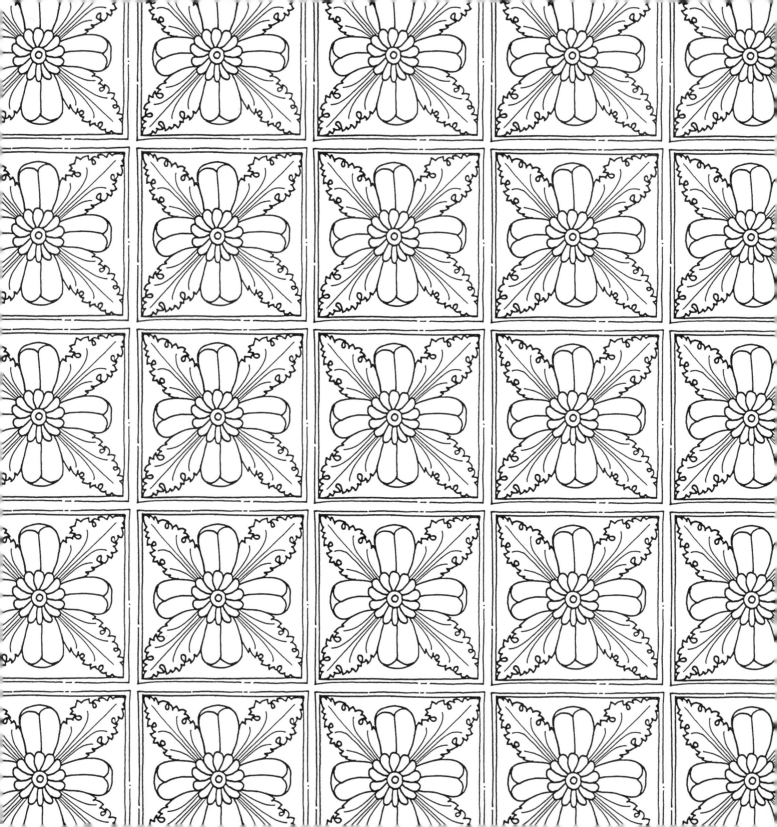

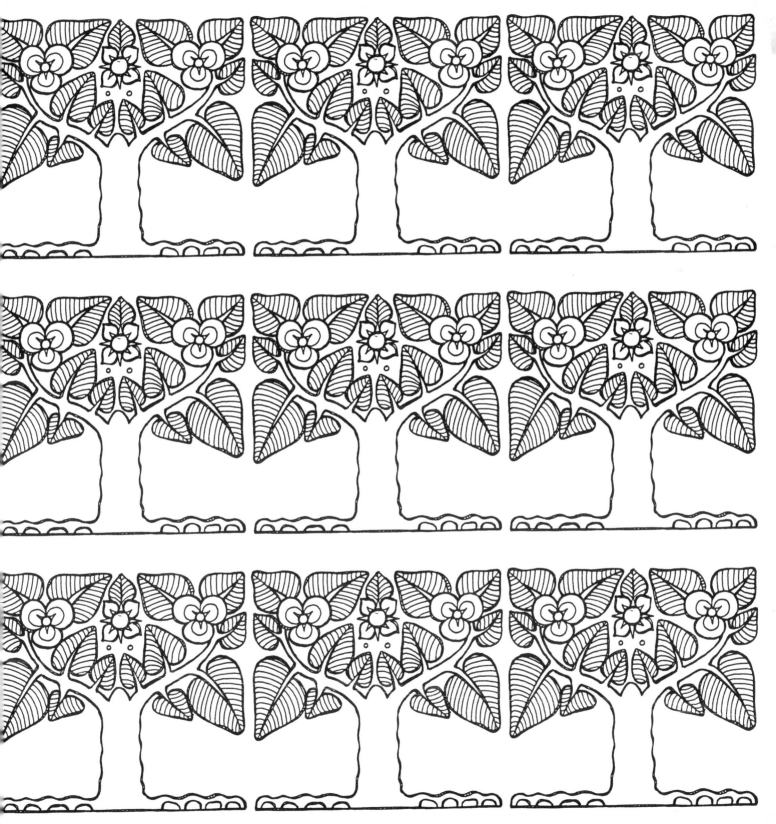

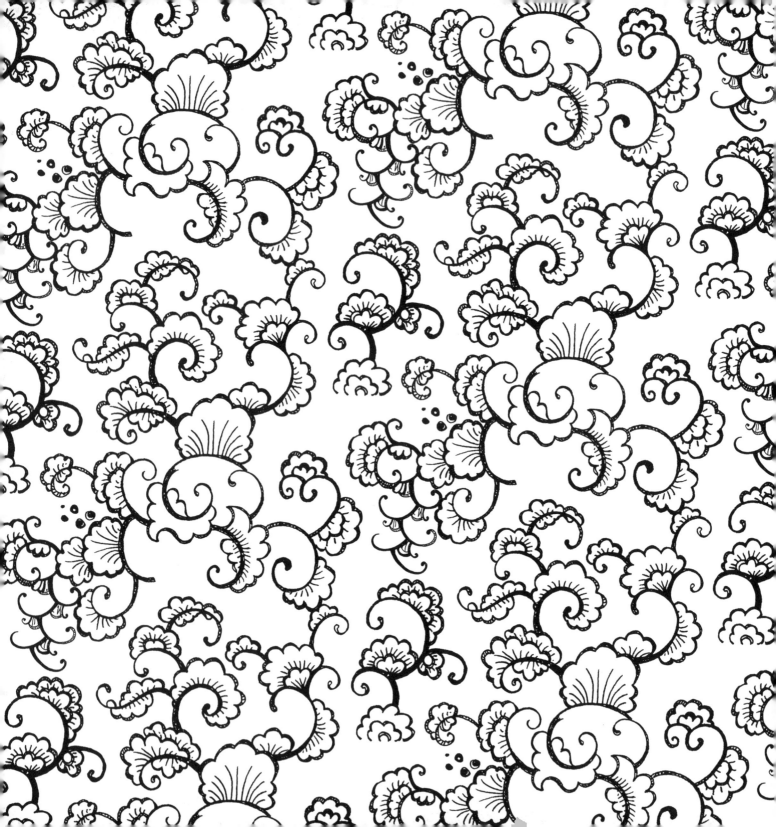

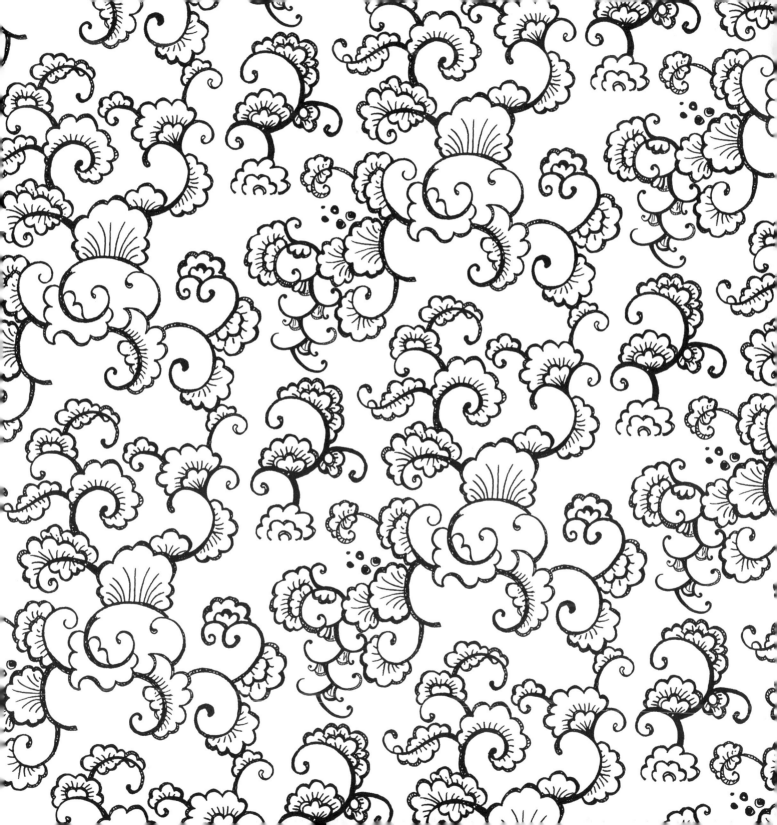

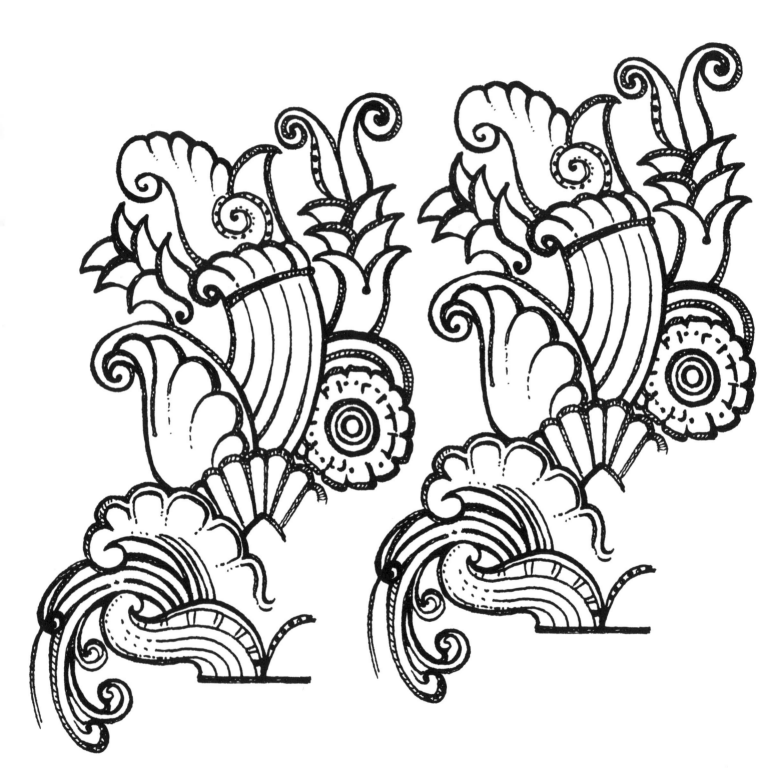

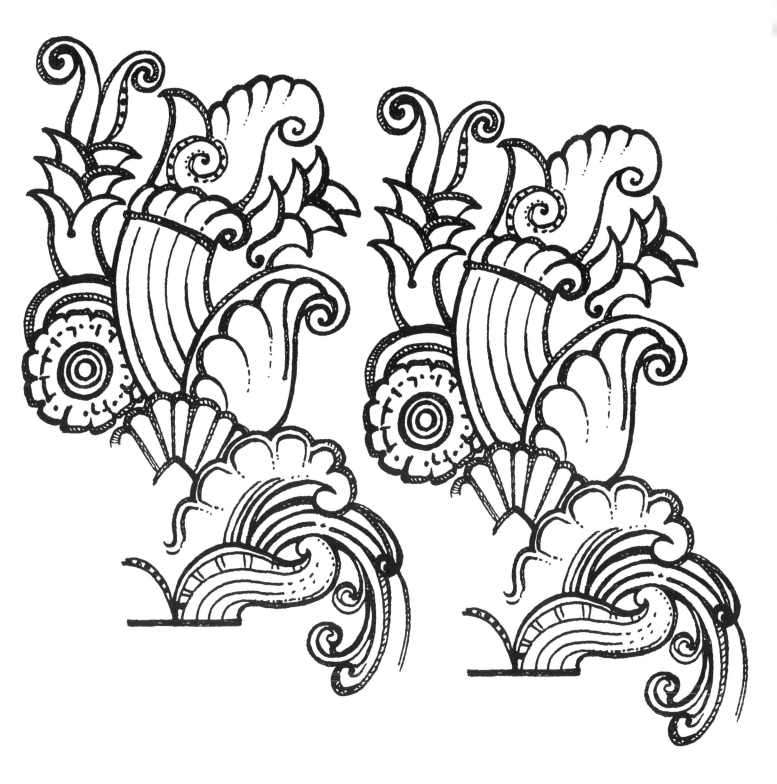

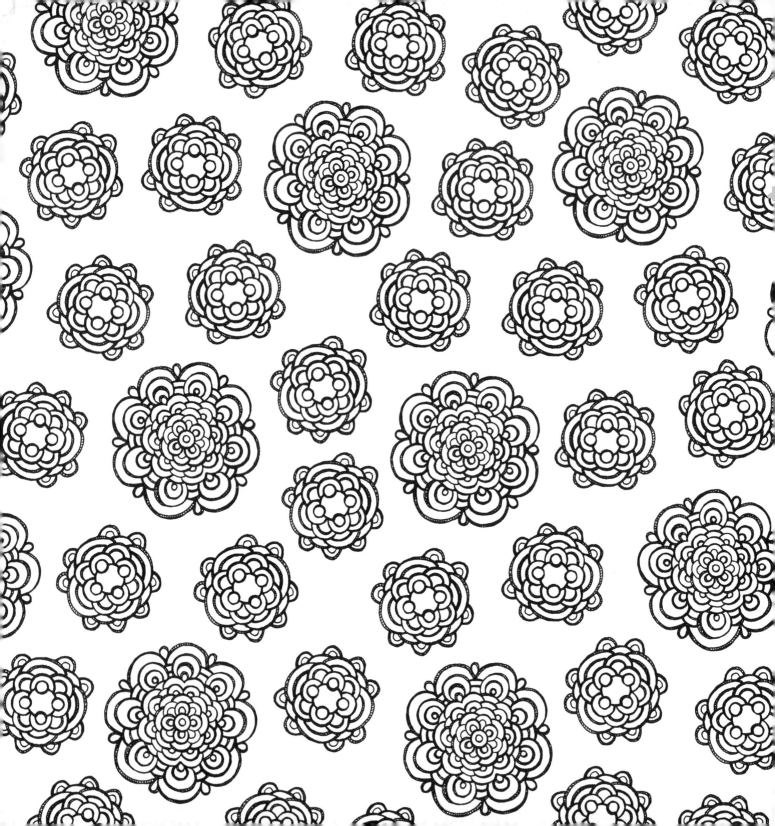

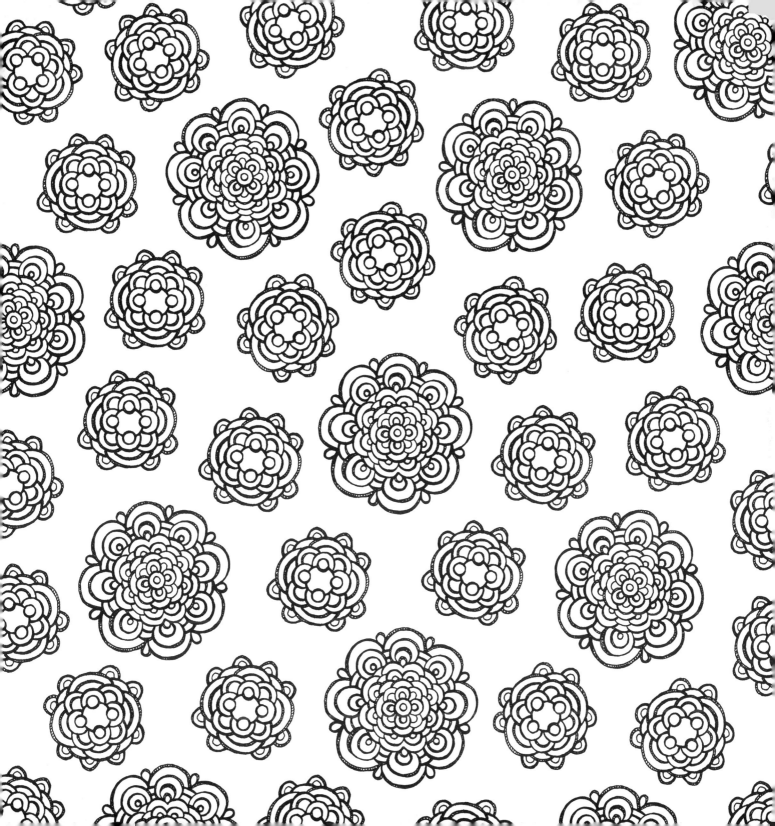

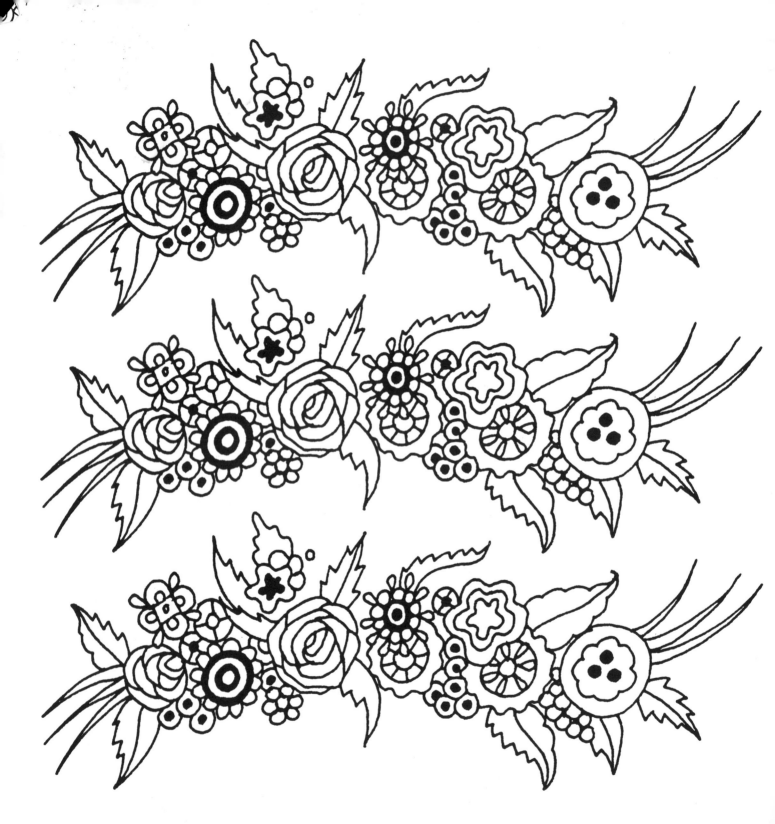